This book belongs to

Includes 50 coloring designs from Selina's Fantasy Art Coloring Books-

Gothic - Dark Fantasy Coloring Book
Night Magic - Gothic and Halloween Coloring Book

As an artist, color is a thing of magic in my life. Color creates shapes, forms, and feelings in the artworks I paint. Laying color onto a blank page is when I feel closest to true magic, when I feel happiest and most relaxed, and it's through what I create that I share my love of magic with the world. Through my coloring books I want to share that same magic with you.

The artworks in my books are based on my completed paintings, which I have painted over the last ten years as a professional artist. I have created the coloring designs to be a mix of intricate and detailed while still fun and accessible. There is something for lovers of meditative detail while simple enough to not be overwhelming for younger colorists. *~ Selina*

See the colors the artist chose for her paintings at www.selinafenech.com

**Gothic Minis - Pocket Sized Dark Fantasy Art
Coloring Book by Selina Fenech**
First Published September 2016
Published by Fairies and Fantasy PTY LTD
ISBN: 978-0-9945852-5-7

Using This Book

Turn off and move away from distractions. Relax into the peaceful process of coloring and enjoy the magic of these fantasy images.

This book works best with color pencils or markers. Wet mediums should be used sparingly. Slip a piece of card behind the image you're working on in case the markers bleed through.

Take this book with you for coloring on the go! It's designed to be small and light enough to be portable.

Never run out of fantasy coloring pages by signing up to Selina's newsletter. Get free downloadable pages and updates on new books at -
selinafenech.com/free-coloring-sampler/

Share Your Work

Share on Instagram with **#colorselina** to be included in Selina's coloring gallery, and visit the gallery for inspiration.

selinafenech.com/coloringgallery

"Darkling"

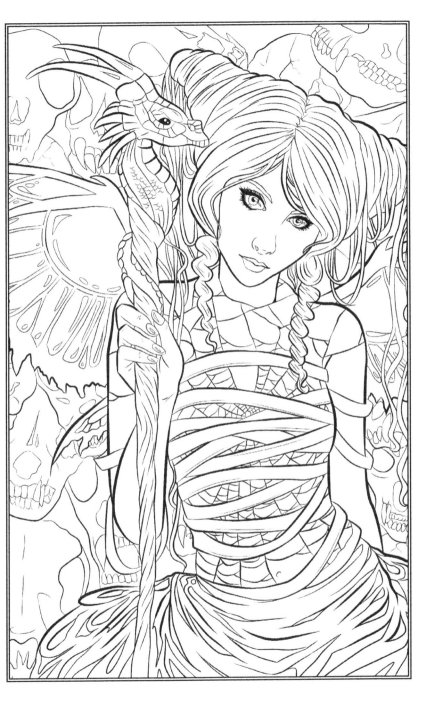

"Bonded"

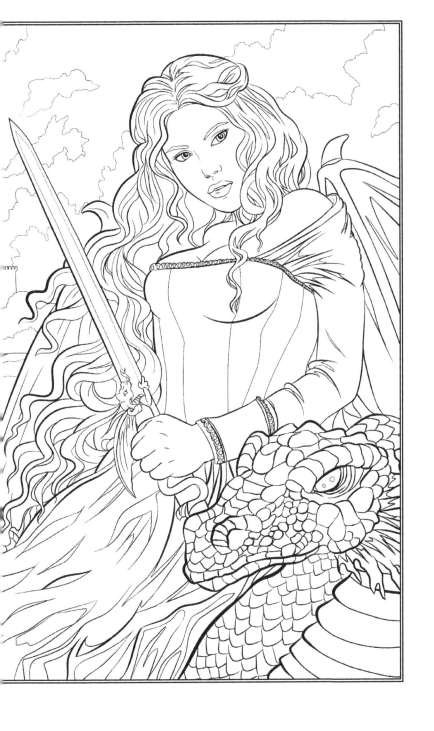

"Autumn in Lace"

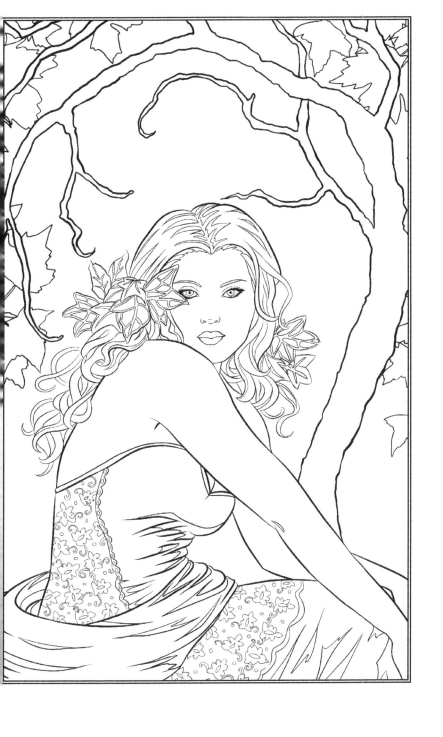

"Clockwork Heart"

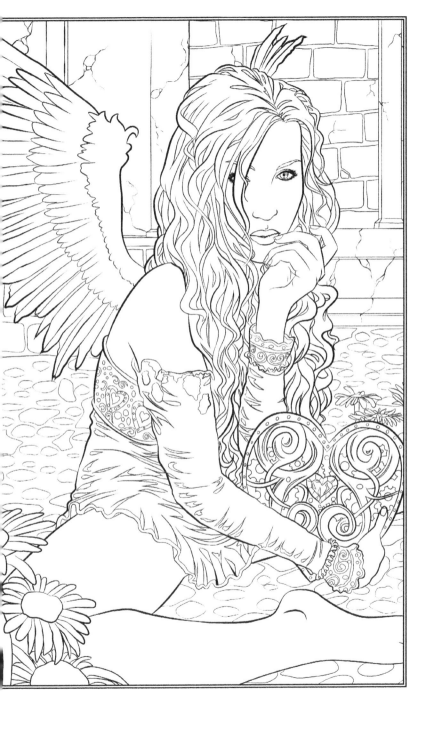

"Fairytales"

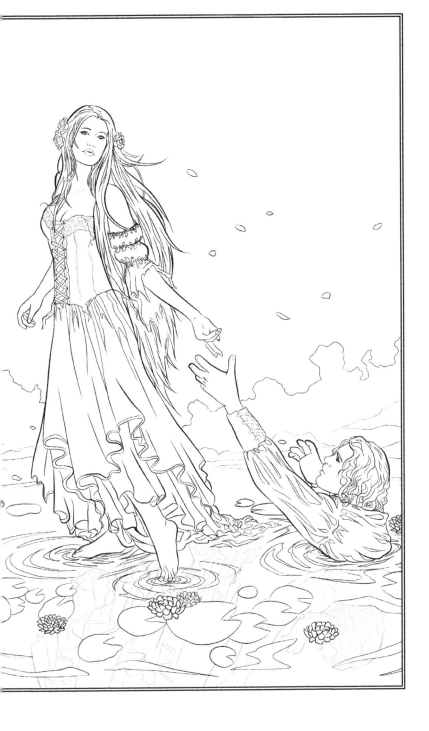

"I Knew Him Well"

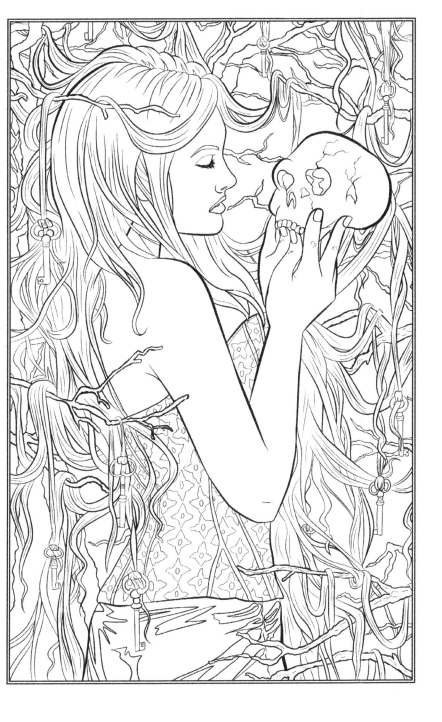

"Lost Soul"

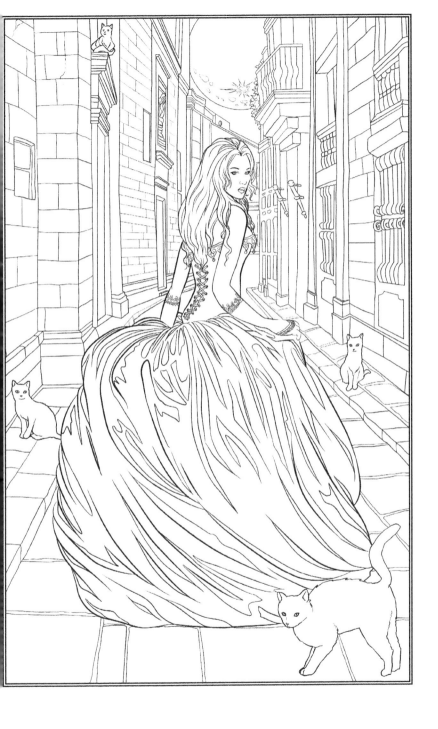

"Lovers Embrace"

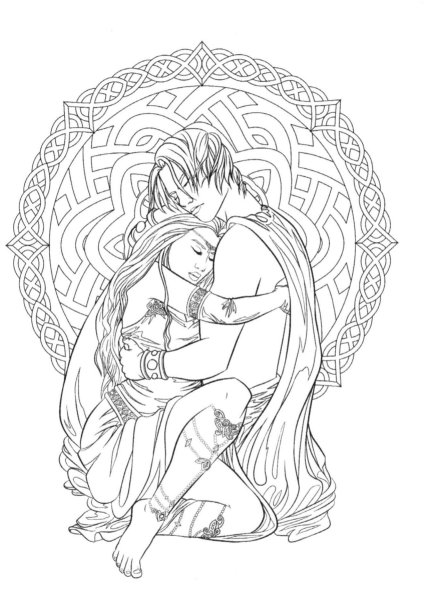

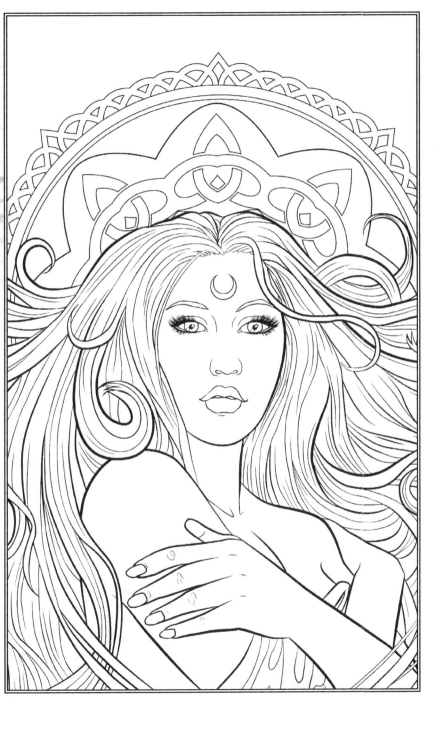

"My Lost Love"

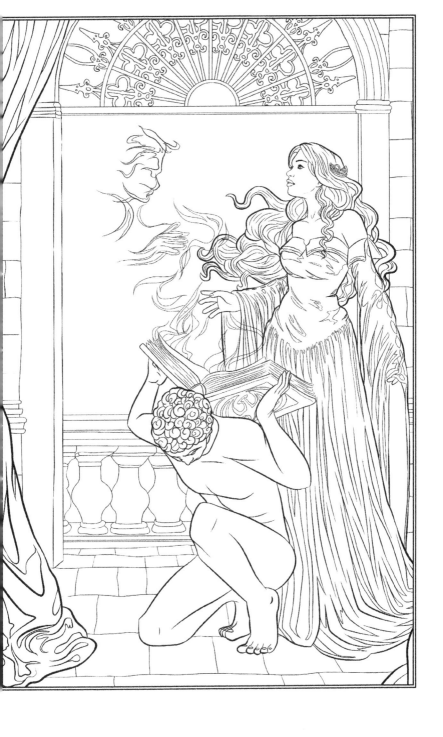

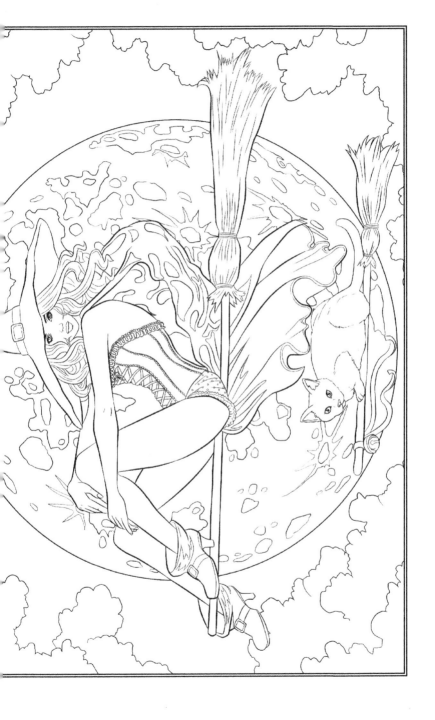

"Jinxed"

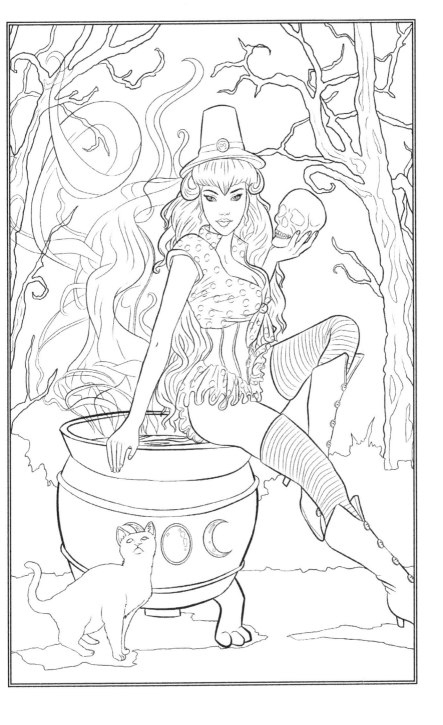

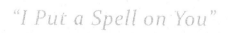

"I Put a Spell on You"

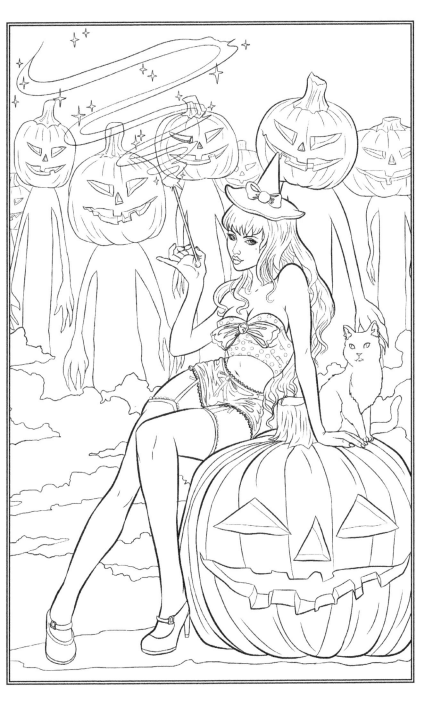

"Rooftop Vigil"

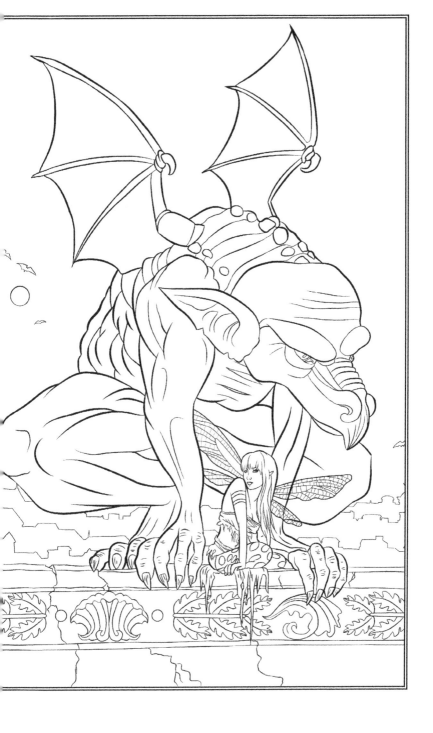

"Rose"

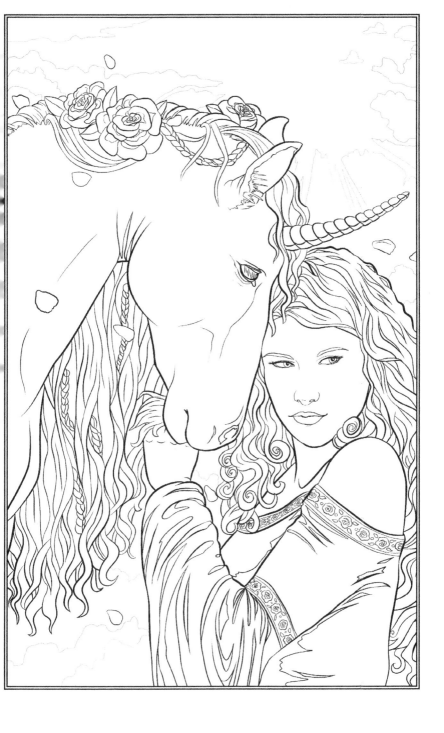

"Storykeeper"

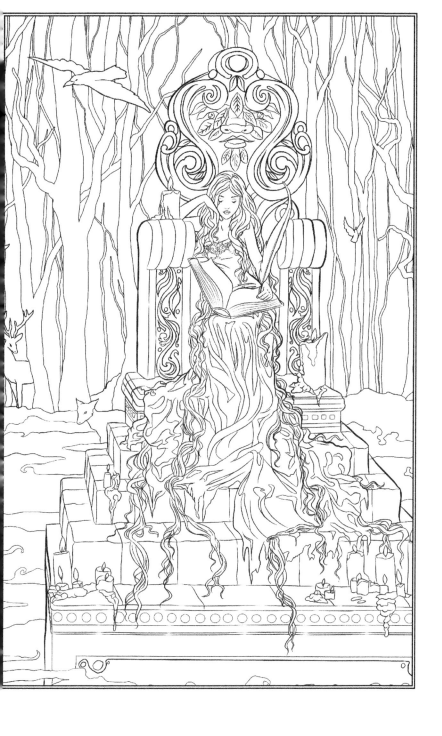

"Tomboy"

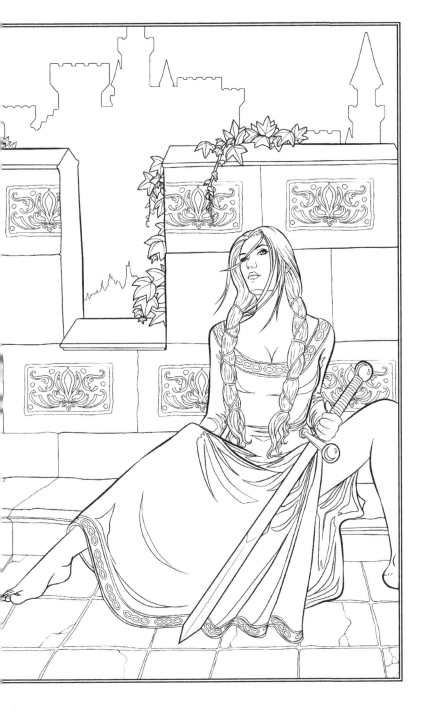

"Torn"

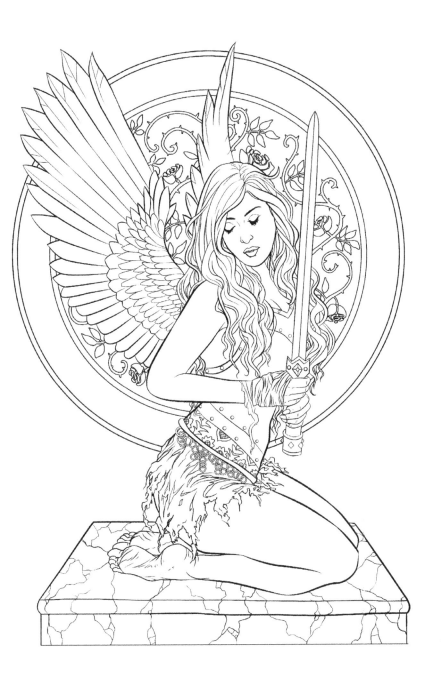

"Raven's Call"

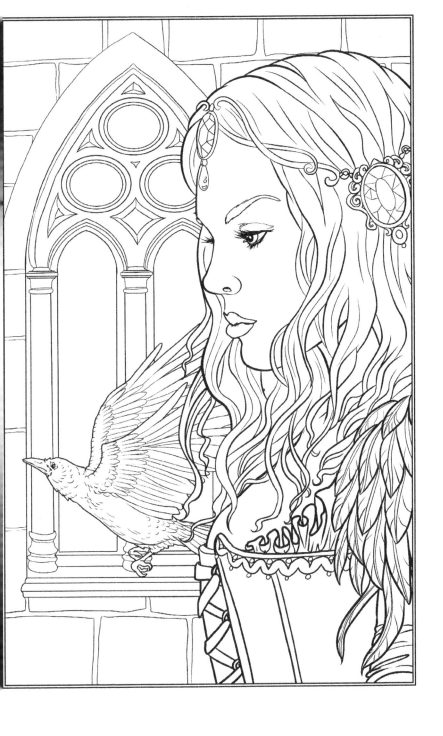

"Full Moon Magic"

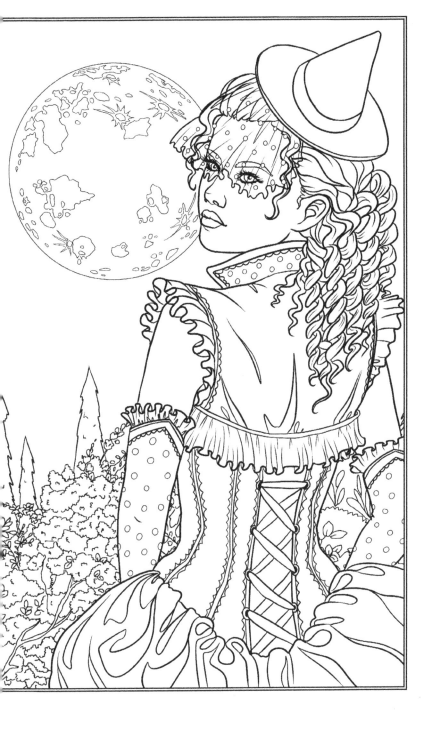

"We are Just Ghosts"

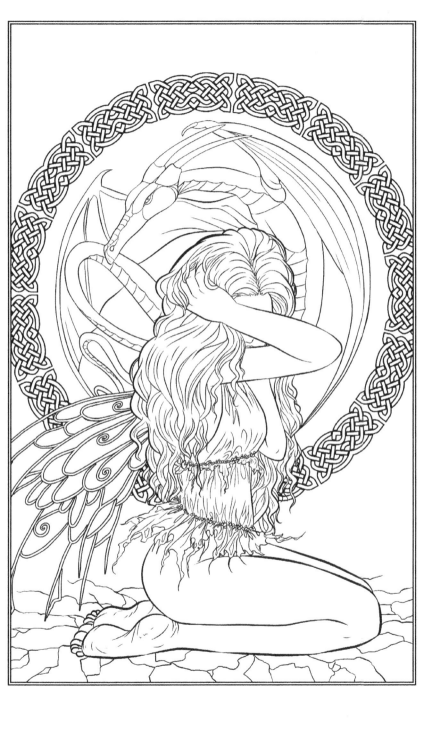

"What Price, Victory?"

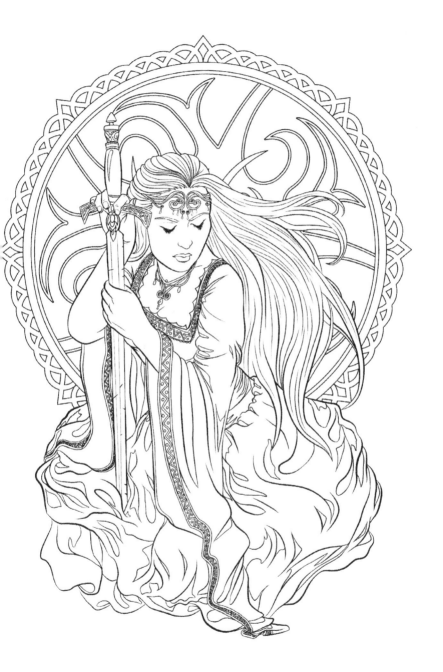

"Biding"

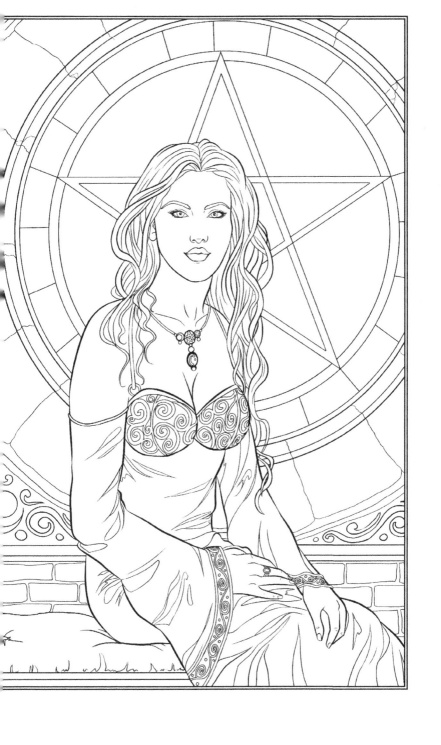

"Within the Coffin"

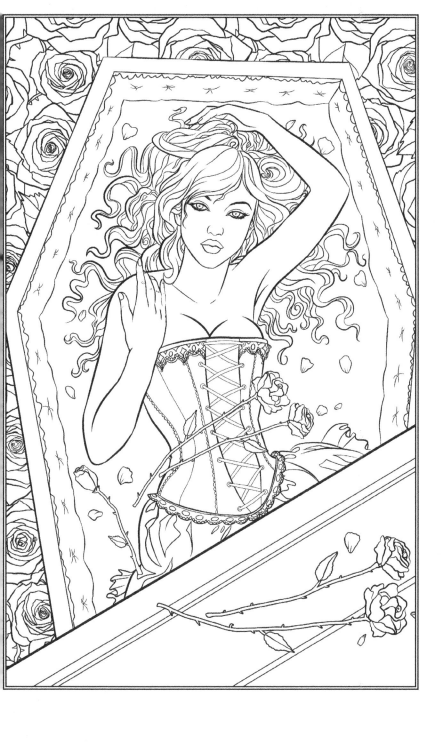

"Guarded"

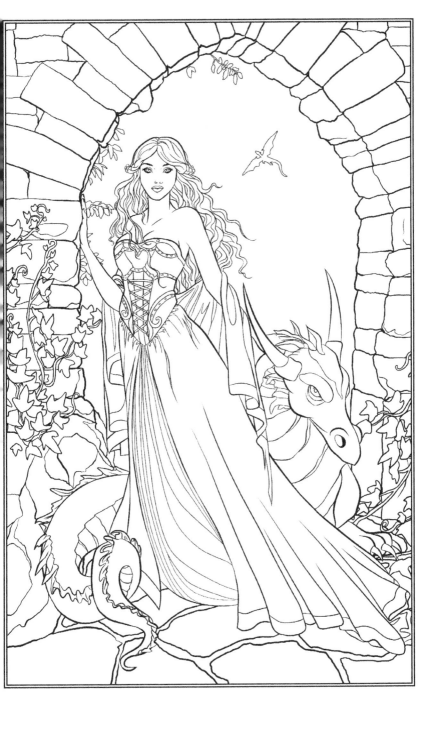

"Where Magic Lives"

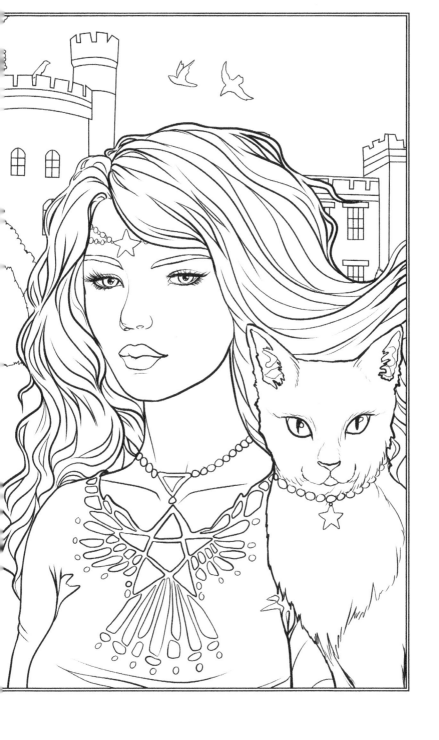

"Night Magic"

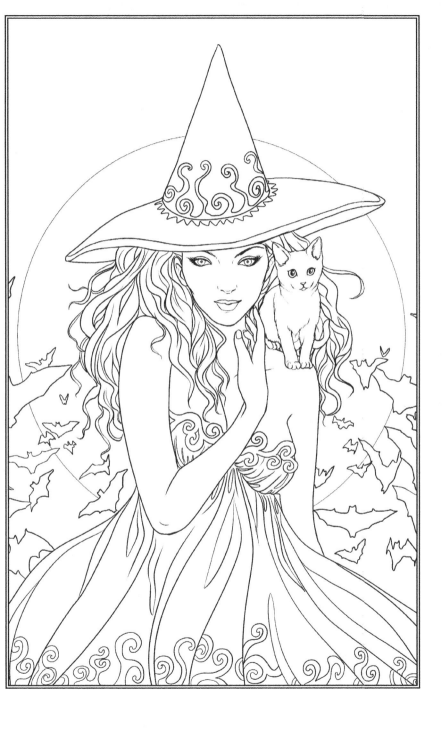

"Halloween Angel"

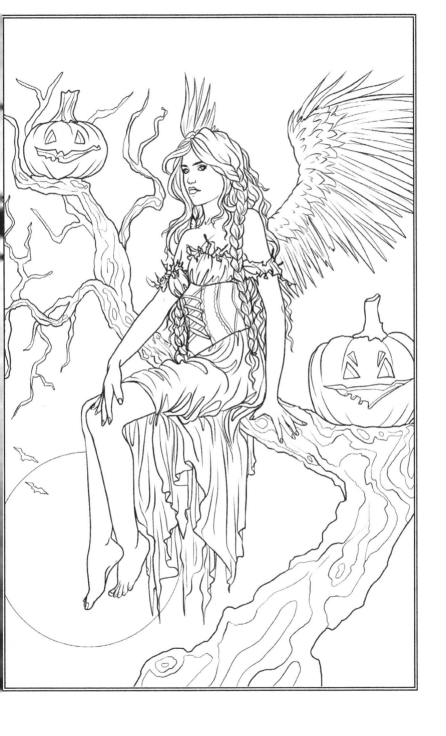

"Is Anyone Home?"

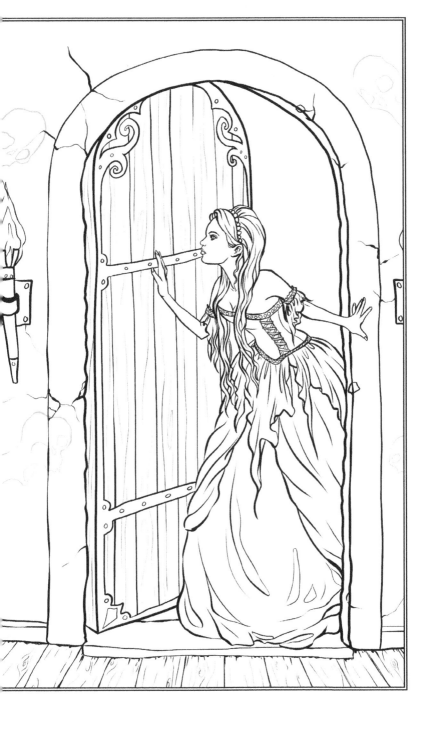

"Whisper"

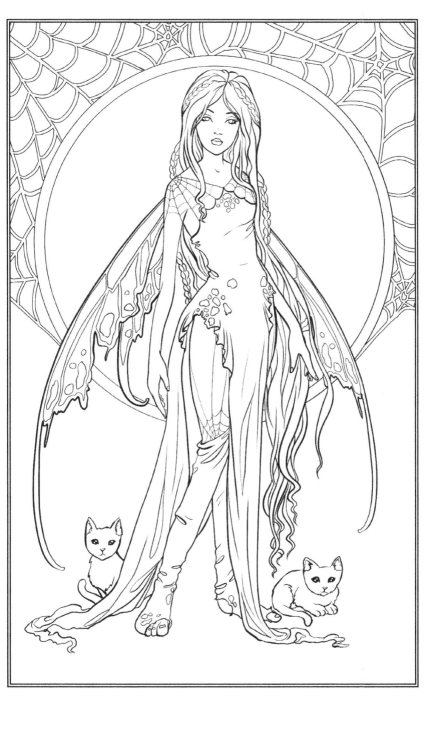

"Dreamlike"

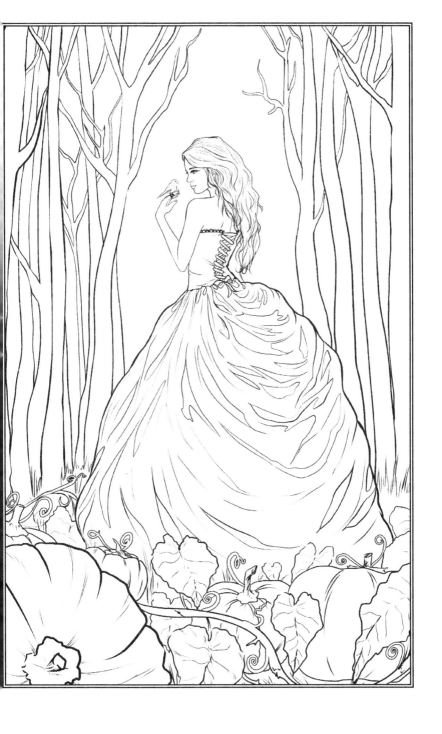

*"The Cold Doesn't Bother
Creatures of the Night"*

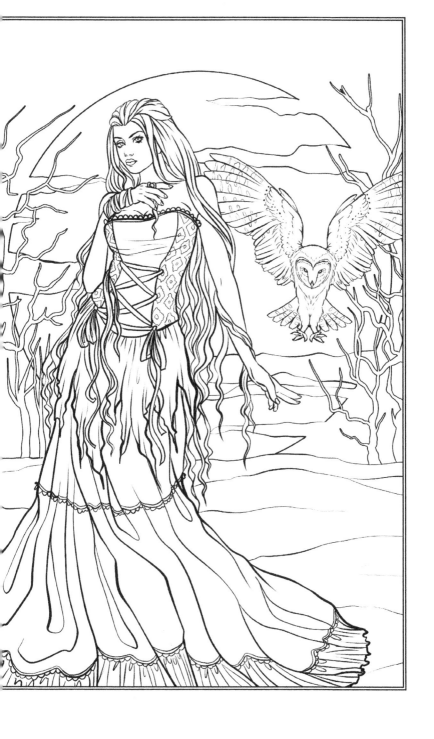

"Autumn Spell"

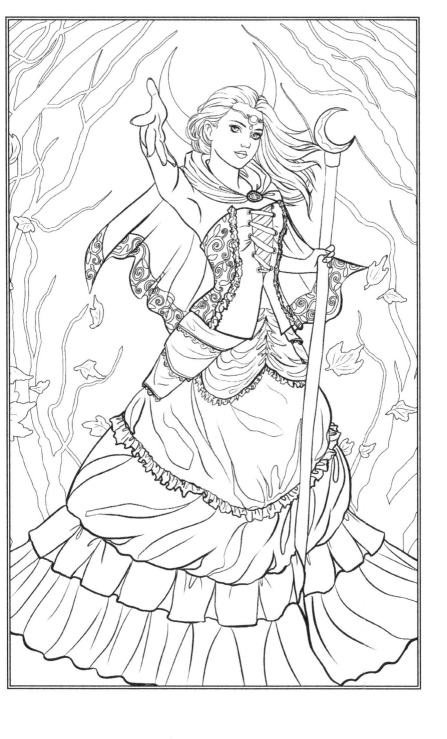

"Beauty and the Beasts"

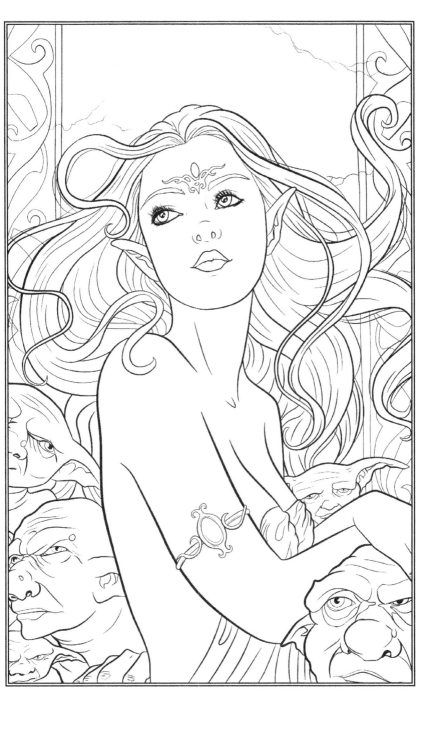

"Dark Moon"

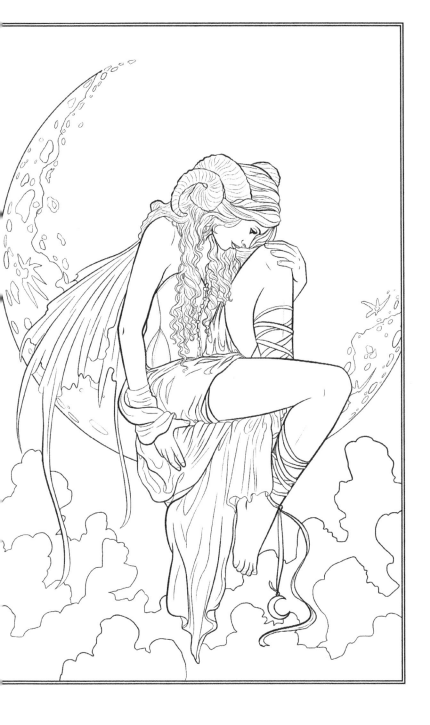

"Dark Angel"

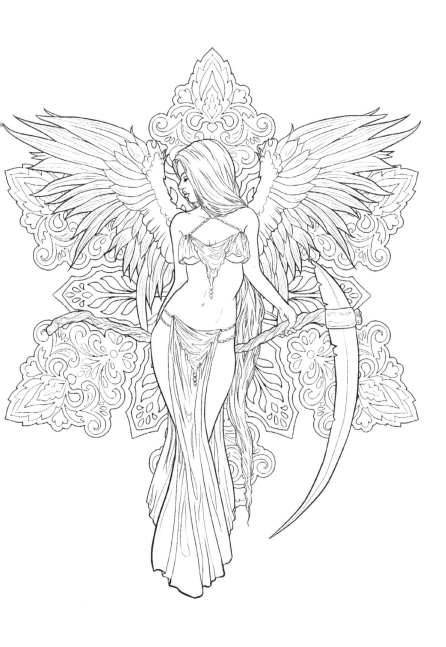

"Fallen"

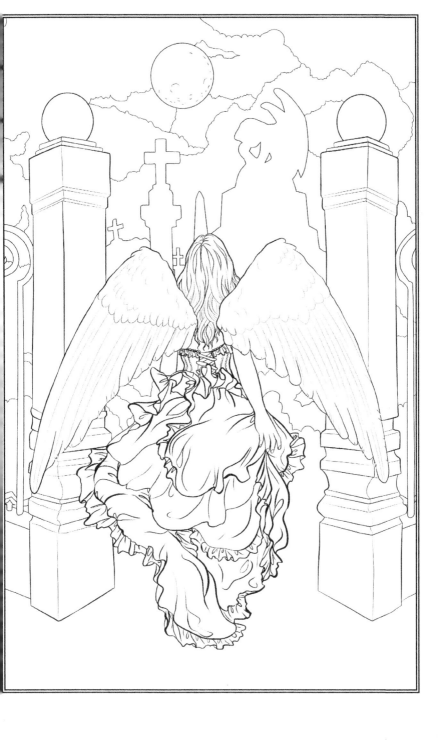

"Stolen in her Sleep"

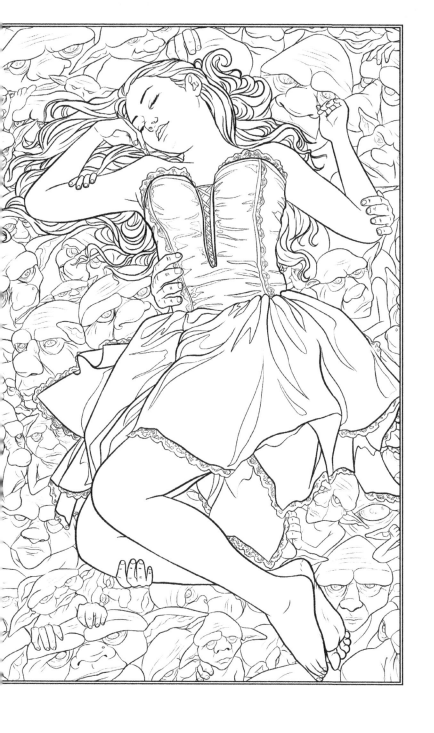

"Castle of the Wolf"

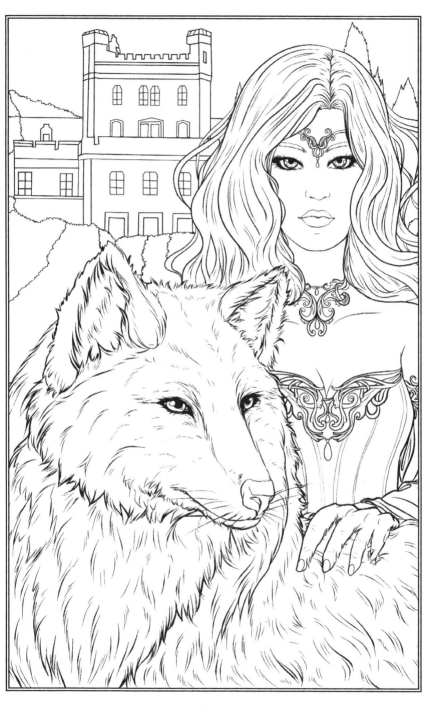

"At the Ball"

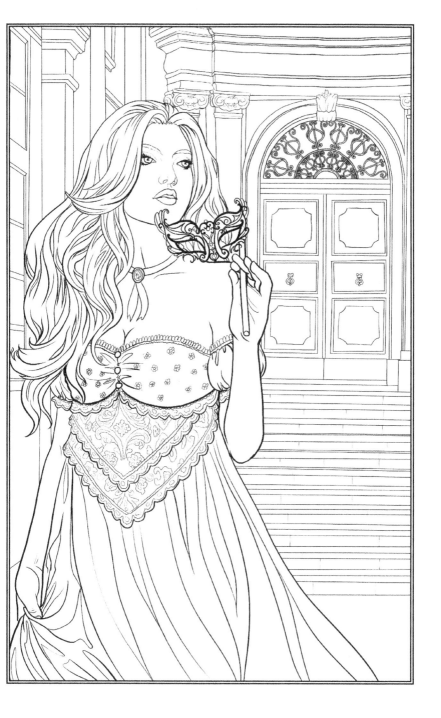

"Enchanting the Stones"

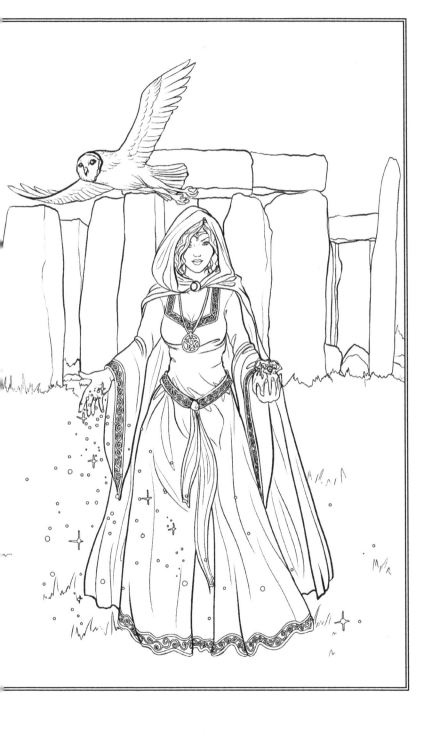

"Pumpkin Princess"

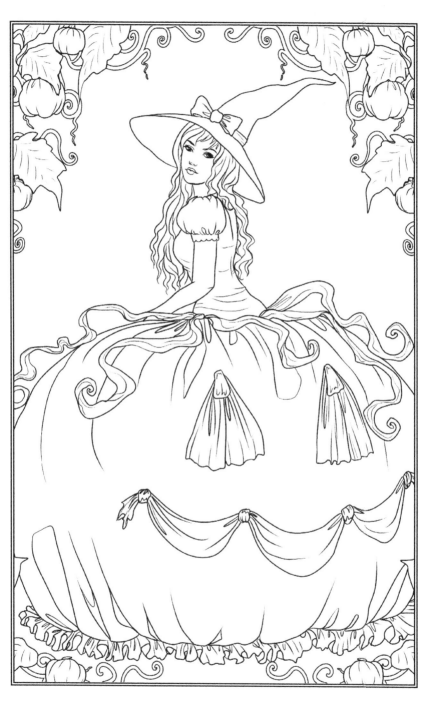

"Night Queen"

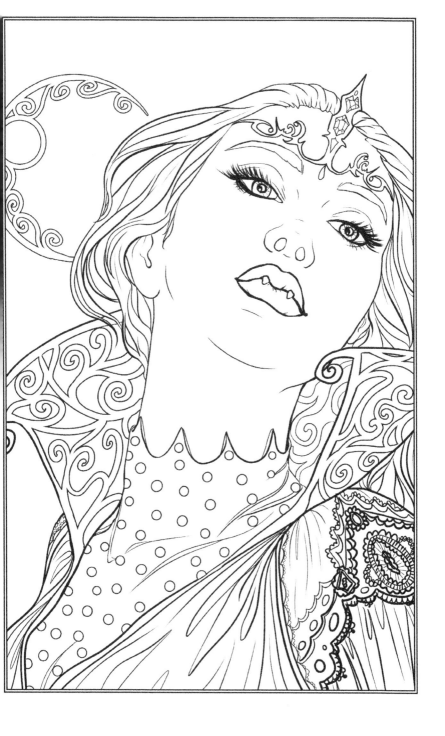

"Shades"

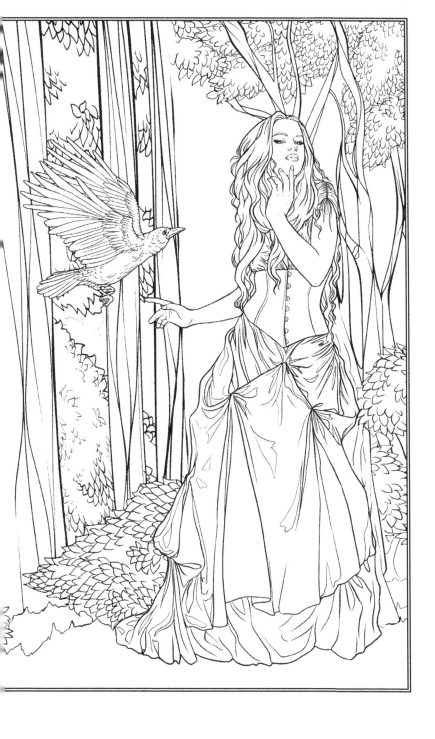

"Sisters of the Night"

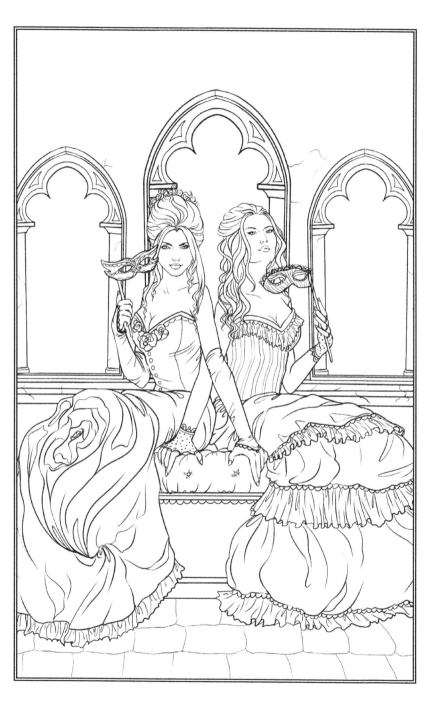

"Vampire Princess"

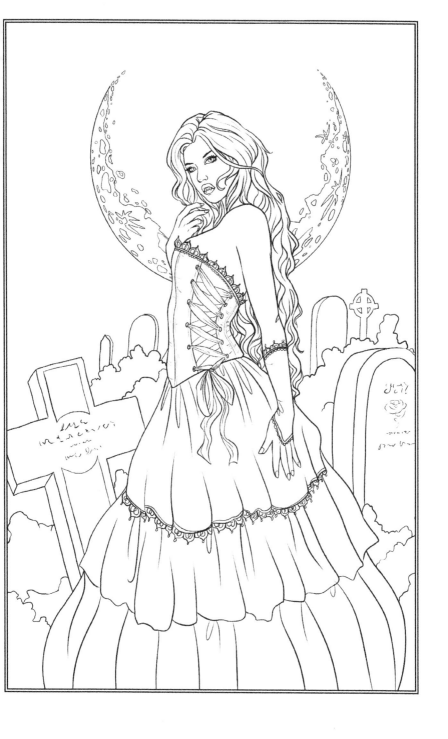

"Let Darkness Fall"

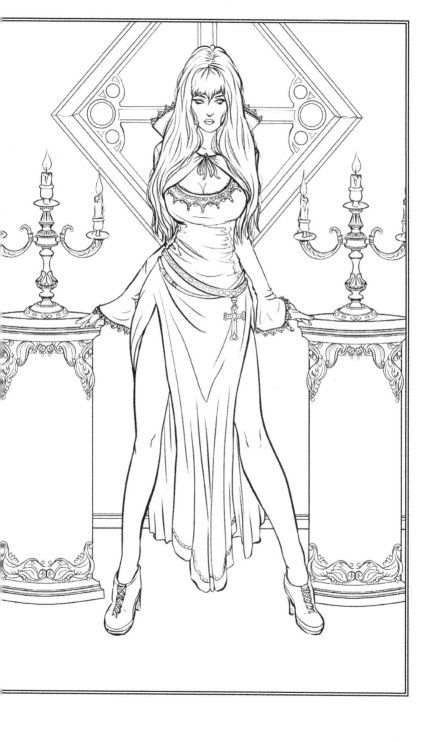

"Come Fly with Me"

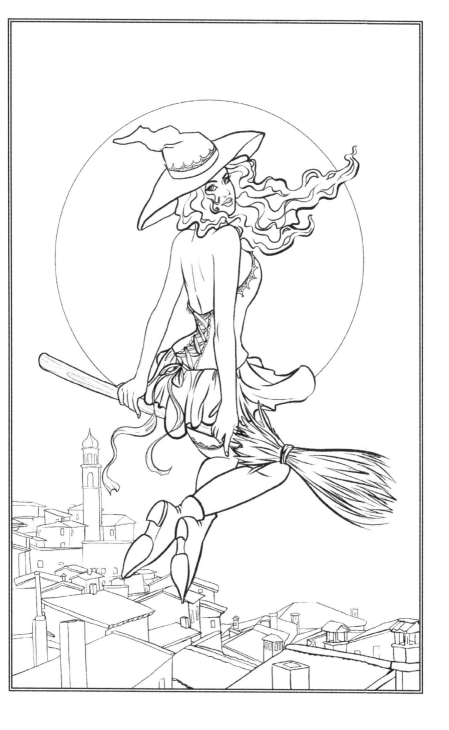

"Voodoo"

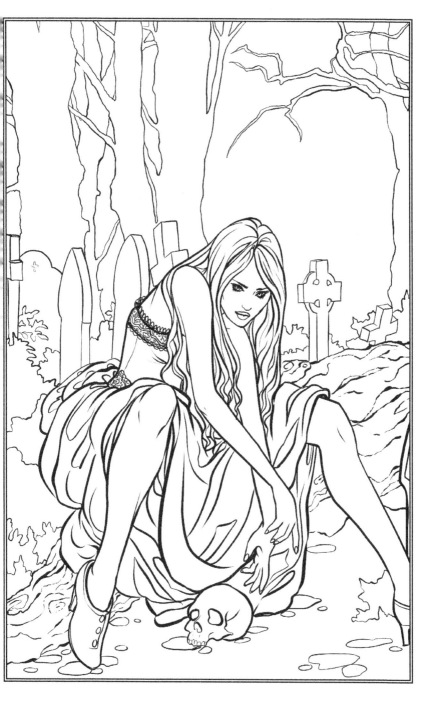

"Autumn Magic"

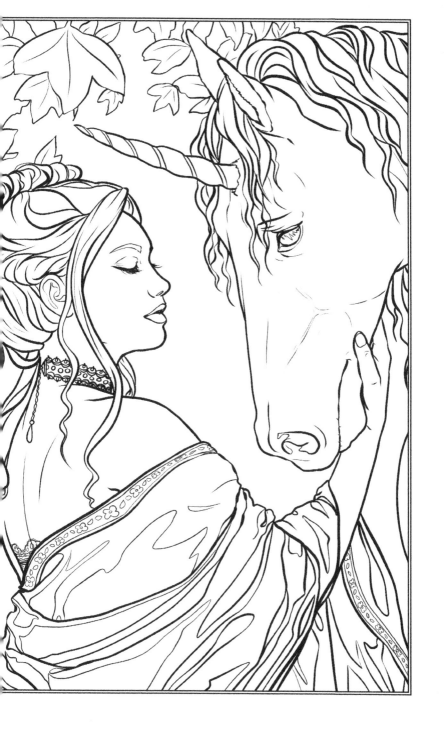

About the Artist

As a lover of all things fantasy, Selina has made a living as an artist since she was 23 years old selling her magical creations. Her works range from oil paintings to oracle decks, dolls to digital scrapbooking, plus Young Adult novels, jewelry, and coloring books.

Born in 1981 to Australian and Maltese parents, Selina lives in Australia with her husband and daughter. She loves food, gardening, geekery and all things magical.

FAIRY
COLORING BOOK
SELINA FENECH

MERMAIDS
COLORING COLLECTION
SELINA FENECH

GOTHIC
COLORING BOOK
SELINA FENECH

FAIRY ART
COLORING BOOK
SELINA FENECH

MAGICAL
MINIS
COLORING BOOK
SELINA FENECH

ENCHANTED
COLORING COLLECTION
SELINA FENECH

See all books online at - viewAuthor.at/sfcolor

Made in the USA
Coppell, TX
30 November 2021

66763956R00059